Inside the Lines:
American Muscle

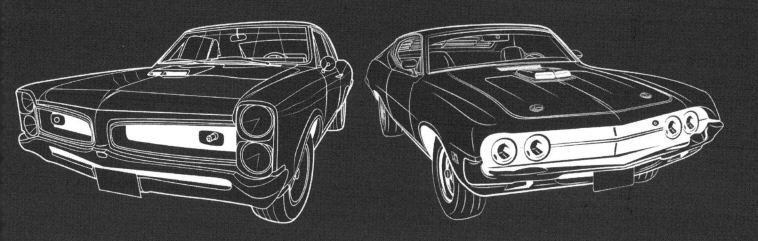

By Brandon & Steve Wilcox

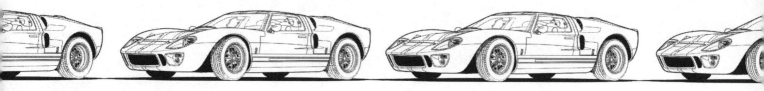

B S W P R E S S
An imprint of sDub Concepts USA
www.sdubconcepts.com

ISBN 978-1536959475

Printed in the USA

Interior designed by Steve Wilcox

This book belongs to:

Introduction

Whether you drive a Honda, Audi, or even a Lamborghini, there's no denying that America's Classic Muscle car era helped shape the enthusiasm we now feel toward our vehicles. Muscle Cars speak to our souls and imaginations in ways that modern cars simply cannot.

Many hours were spent curating a diverse selection of some of the rarest and most valuable vehicles produced in the Untied States of America between the 1960s and '70s. Take a journey through history in this "Name that Car" format coloring adventure. Some will be obvious, but most will require a bit more thought and even research to identify, but we've provided enough information for you to go off of that even the most novice of car enthusiasts will become well versed before its over!

Have fun, be safe, and always stay **Inside the Lines**

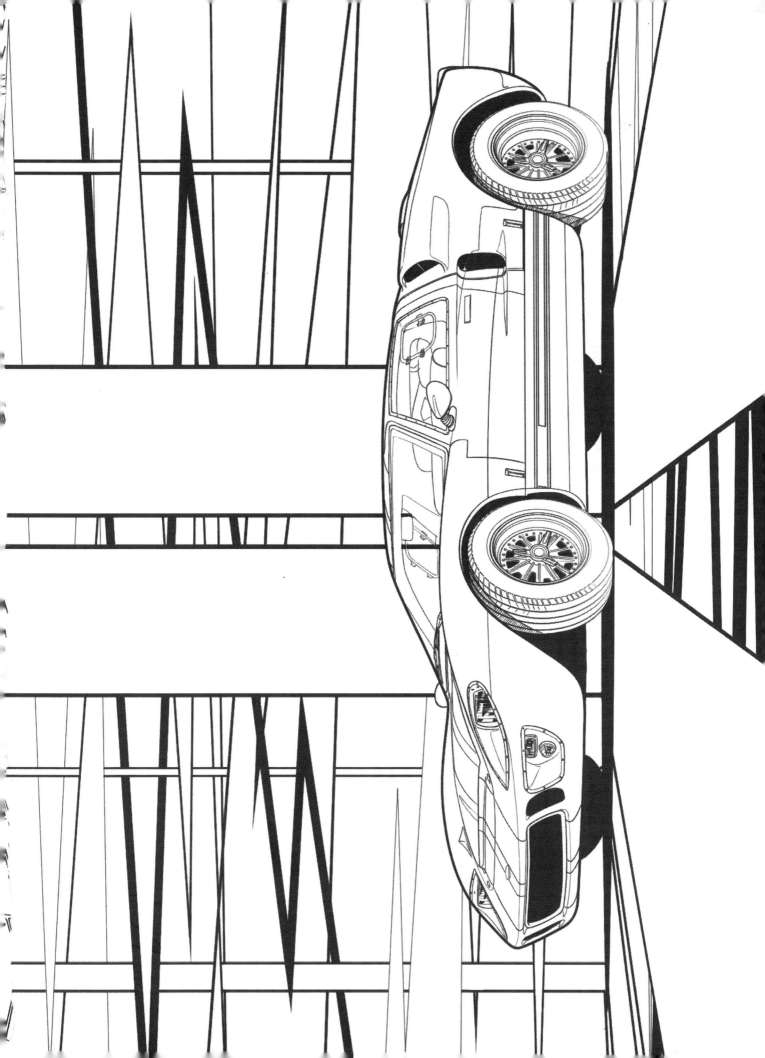

This race car was built with a purpose to compete. In 1966 it even became the first American car to win the Le Mans racing competition. It also won the manufacturers championship the same year and became the most influential project in automotive racing. It's sleek aerodynamic design and 485 horsepower engine packed a top speed of a whopping 205 mph and further cemented its place as an American icon. Can you name that car?

Considered the best of the best by many, this model is extremely rare. Only 20 units were ever produced and sell for $3,850,000 USD these days! A perfect match of beautiful design and terrifying power. It was Dyno-tested at 560 horsepower and is one of the most sought after collectible cars today. Can you name that car?

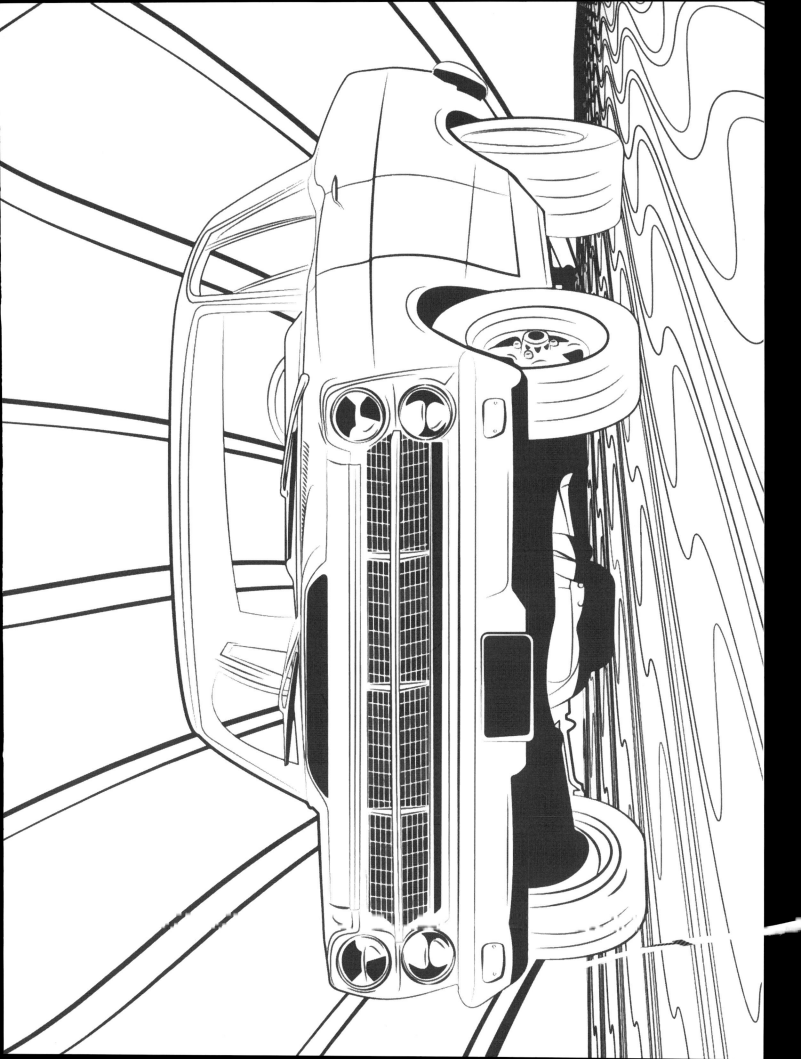

1967 was the introduction to the fifth generation of this vehicle. Most consider the 5th generation its peak. It' accelerated from 0-60mph in 4.95 seconds and packed a 425 horse punch! To this day this vehicle is known as one of the most powerful muscle cars of all time.

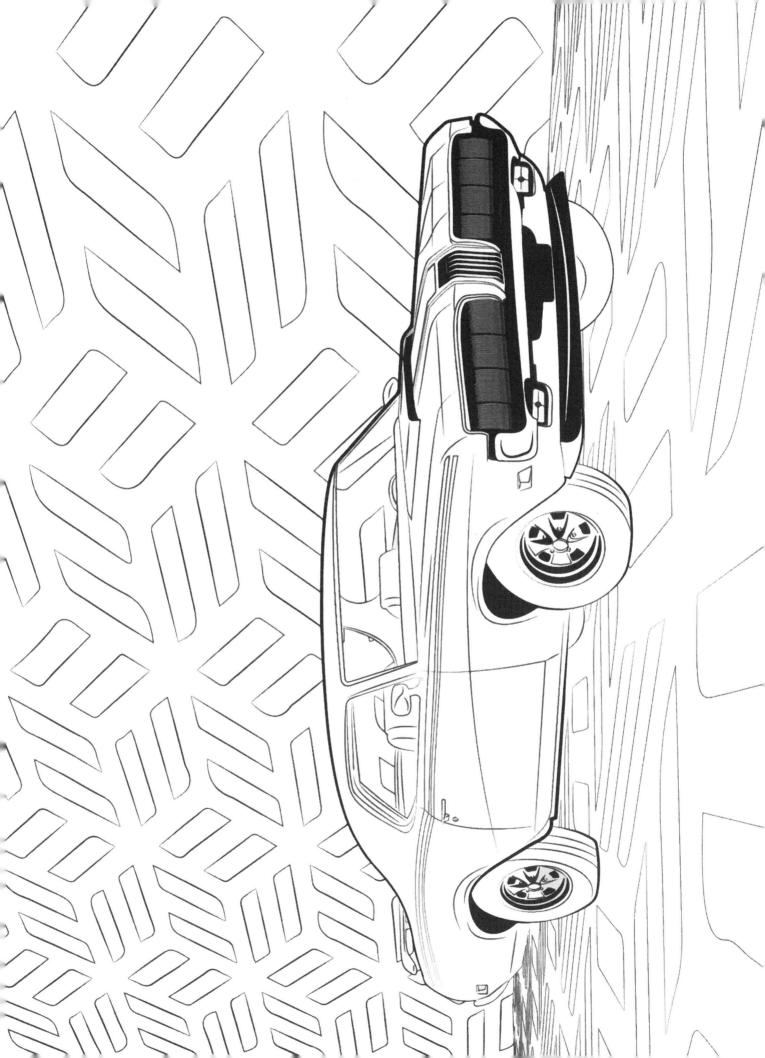

1967 "Car of the year" in many respected automotive magazines, this vehicle was a huge success. Consumers seemed to love the stylish muscular design. Plus with a 335hp V8 engine, It packed power as well! Can you name that car?

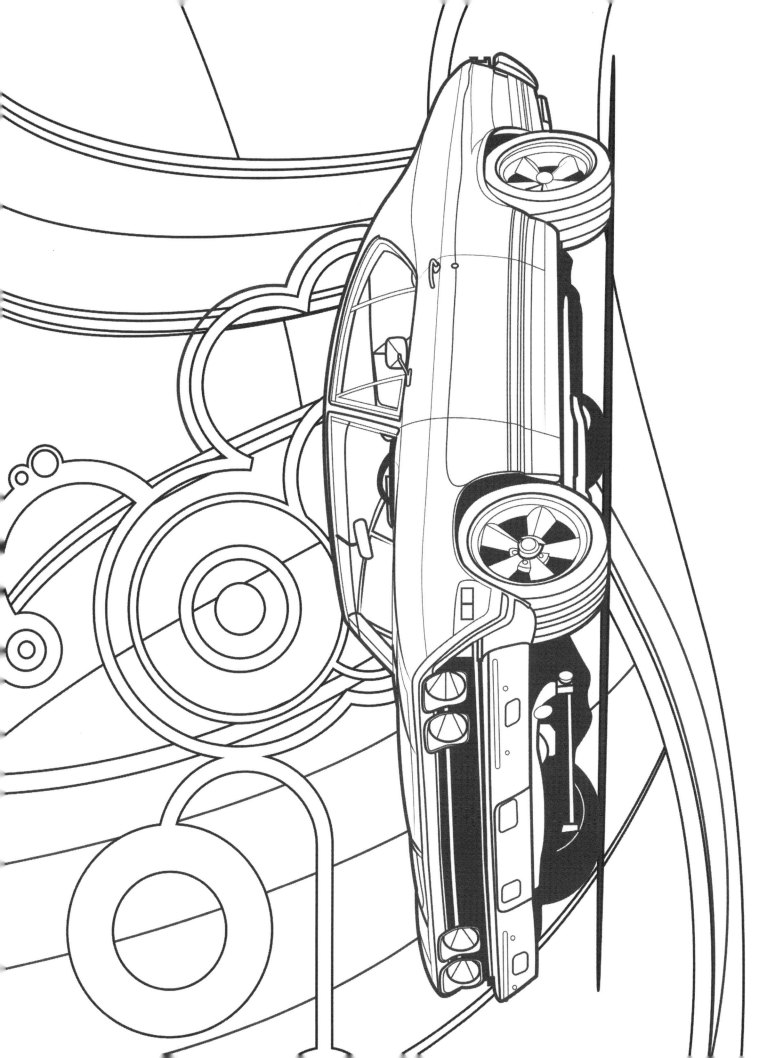

Can you name this classic? Nicknamed "King of the Streets" this is a true heavyweight when it comes to powerful muscle cars. Boasting 450 horses under the hood it's as intimidating performance wise as its outer appearance would indicate. It's cowl induction hood and hood pins gave it a look not to be taken lightly.

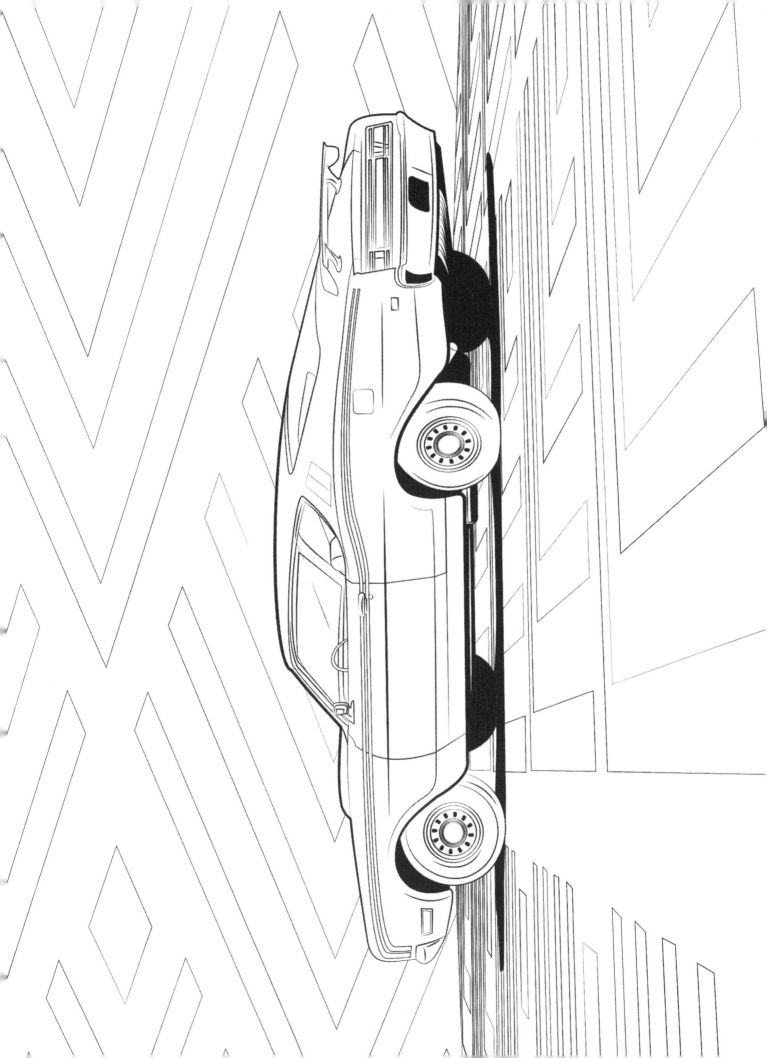

Name this car! In 1968 it was named fastest car of the year. It also set a world record that year for top speed clocking in at 189.22 mph. It had a 325hp V8 engine.

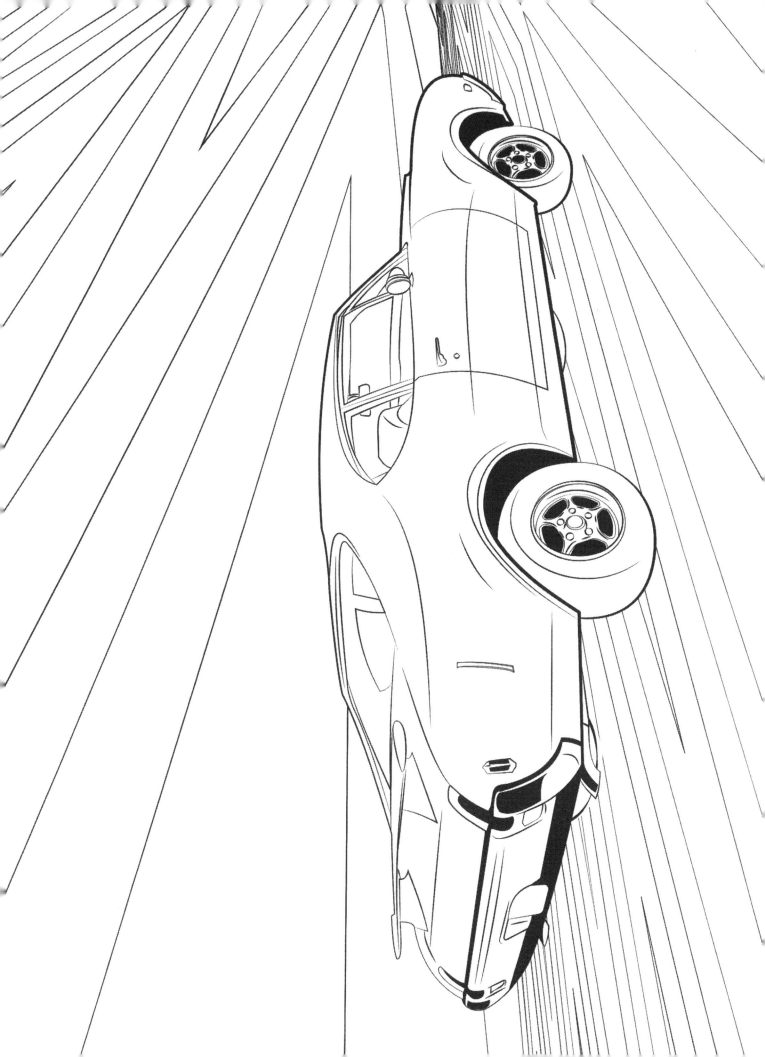

Easily recognizable for its Peruvian silver and black paint schemes and pin striping, this model produced a total of 515 units in 1968. Fitted with performance parts from a collaborative partnership, can you decipher its hyphenated name?

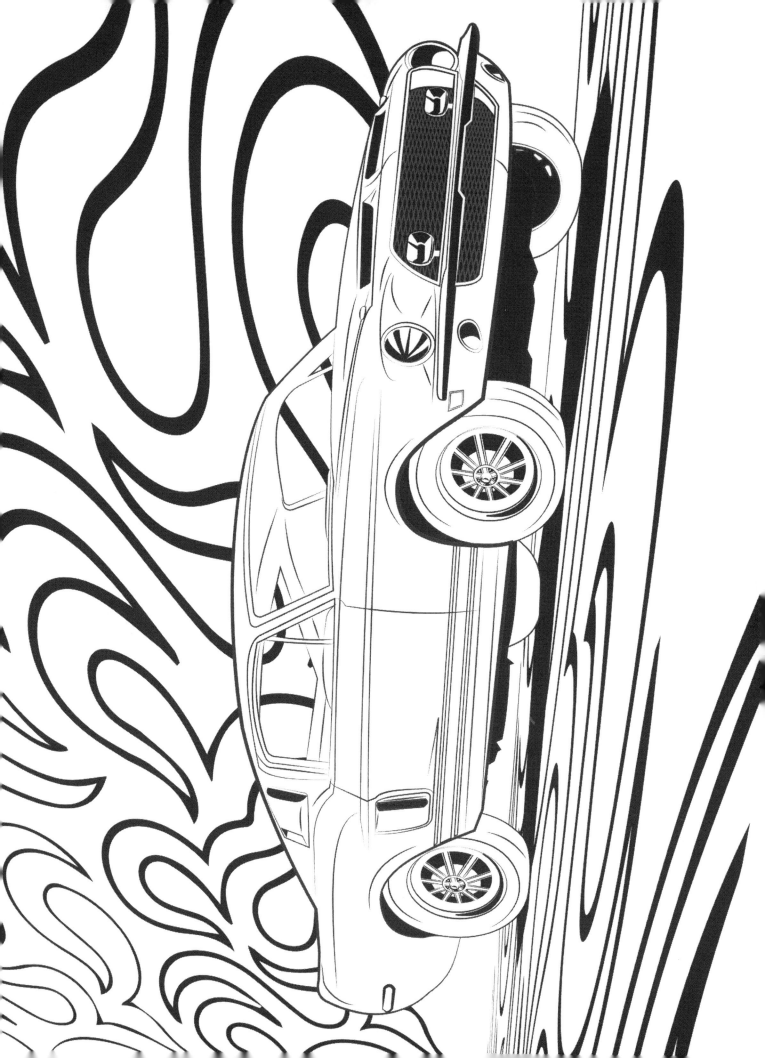

Sure, it's original design is recognizable by everyone, but can you name this beefed up version? Gaining iconic status almost immediately for its style and power, this all American muscle car owned the road. It's 335 horses, 0-60 in 6.5 seconds and sleek yet muscular appearance made this car gone in less then 60 seconds.

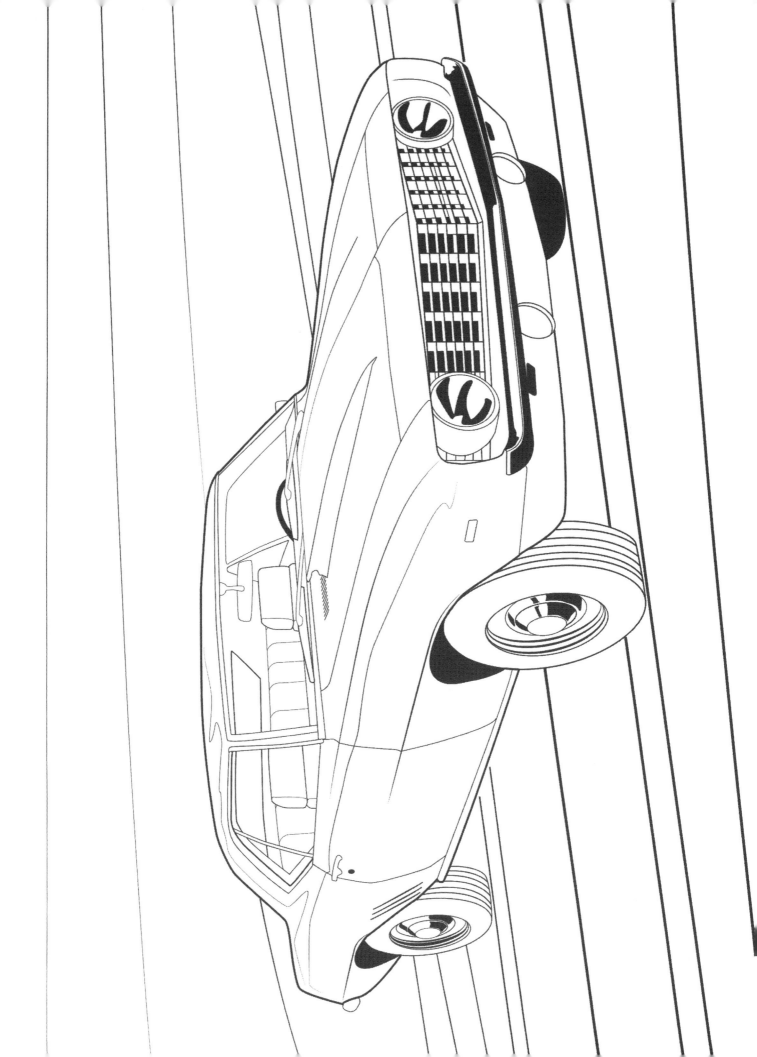

Can you name that car? One of the most highly regarded cars of its era, this classic muscular look was very popular. Not only was the look muscular, but the real power was in its 550 horsepower V8 engine. It's engine made of many aluminum parts made the car lighter weight to be quicker off the line. This helped it obtain a 0-60 time of 5.2 seconds.

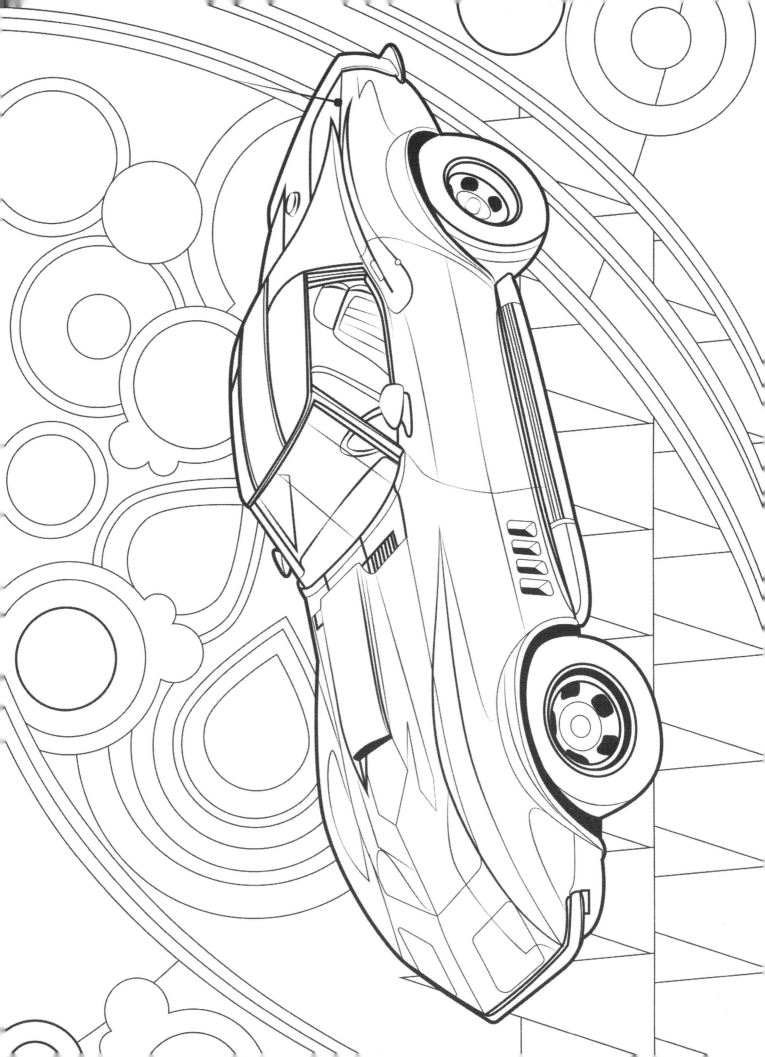

Can you name this model!? It May look recognizable but Only 2 units were ever sold to the public. It was built specifically for racing and not to just compete but to dwarf the competition. It was Fitted with a V8 Aluminum Engine to keep it lightweight and received much success during its run.

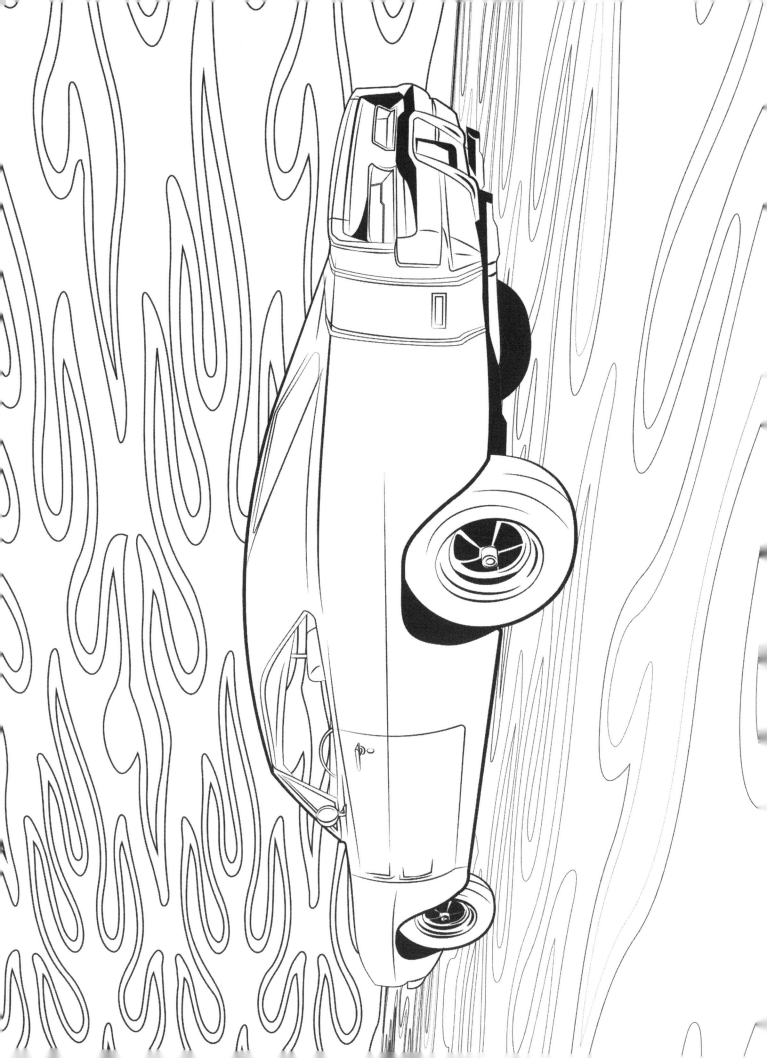

Can you name this highly popular muscle car? The design is acknowledged by muscle car lovers as legendary. It's power is nothing less then the same. It's V8 425 horsepower hemi engine and 0-60 time of 5.4 seconds proves that.

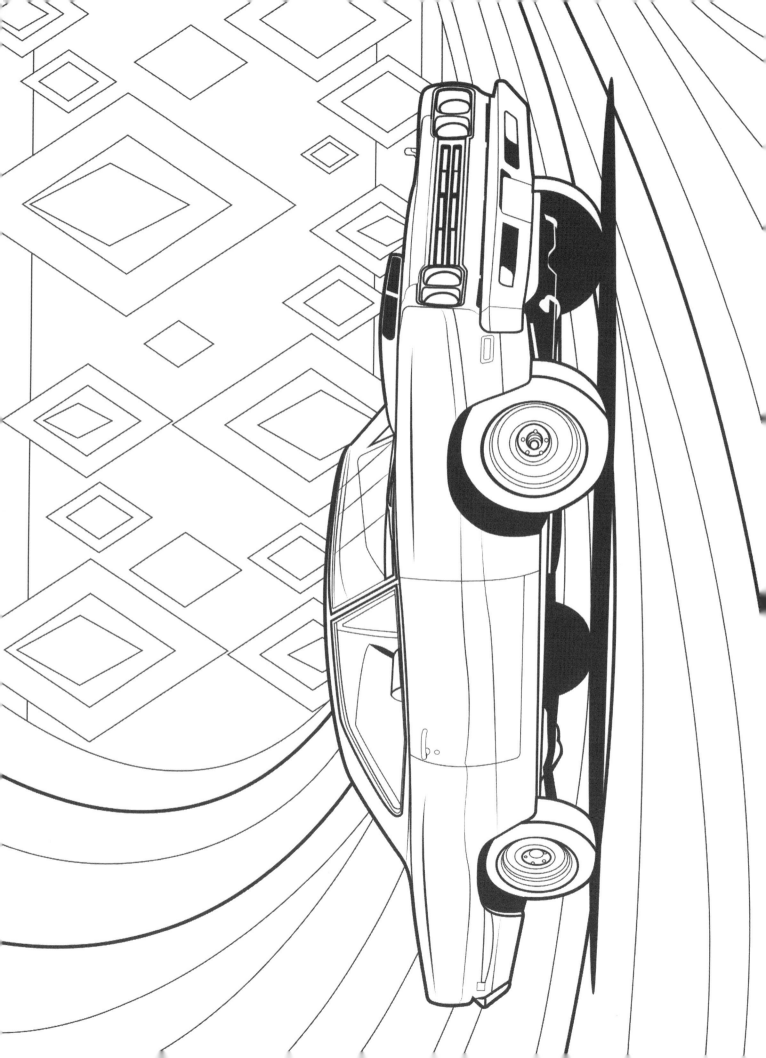

Beep, beep! Built with a focus on performance at an affordable price during a time when muscle cars started increasing prices, this vehicle found great success. Sporting decals of a certain Looney Toons character it even had a horn that sounded like the character! Can you guess which one?

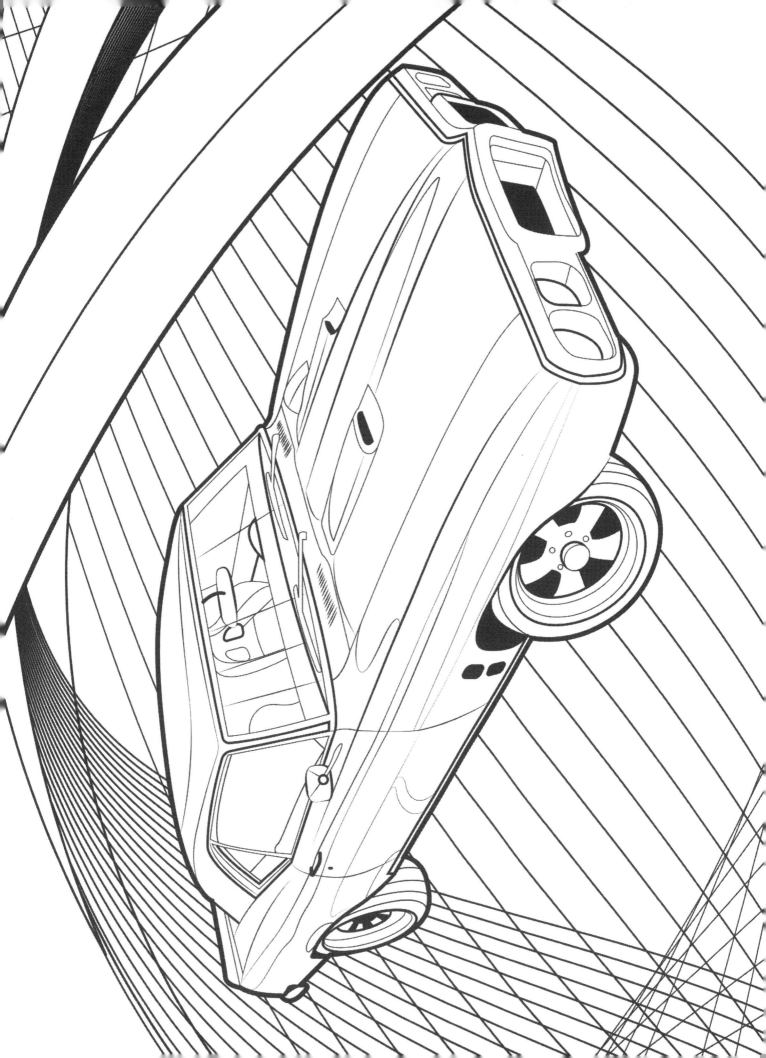

Popular for style and performance at a reasonably cheap price this muscle car was 1 of 2 pony cars continuously produced into the next century. Financially successful the 1969 model is known nowadays for its classic muscle car appearance. Can you name that car?

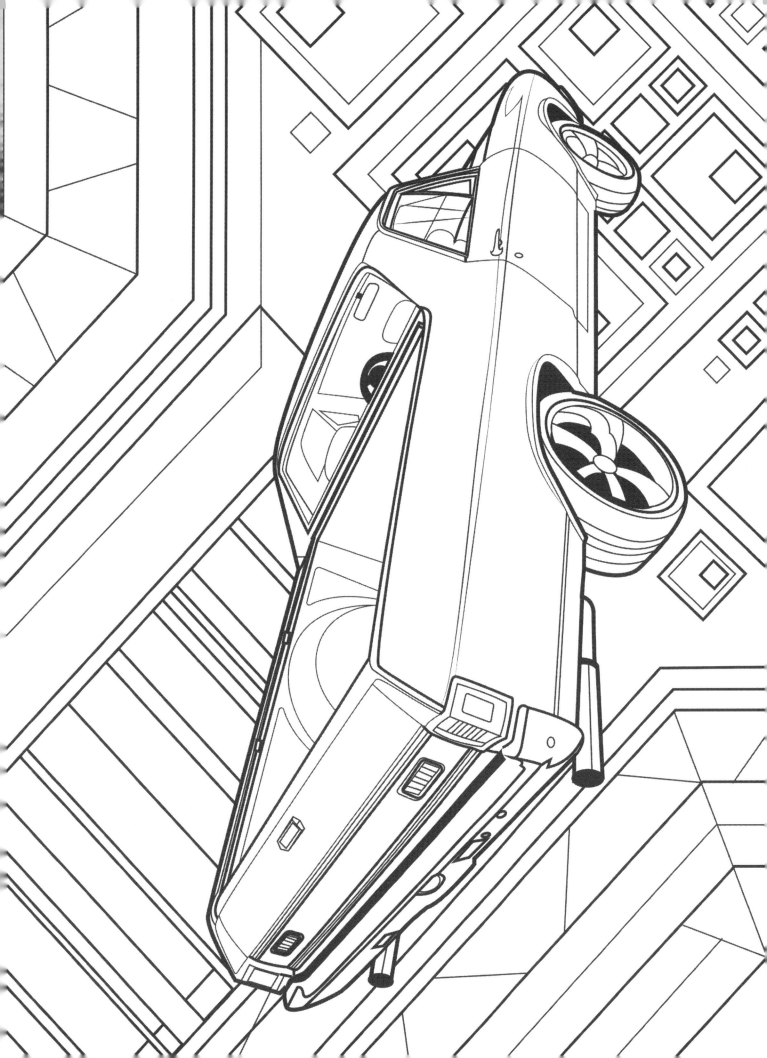

Name this model! Unless you were born yesterday we all should recognize this great American Classic. Technically classified as a truck due to the flat bed design, it was created as a multi-functional vehicle. It's V8 engine also was respectfully powered by 450 horses.

The age of muscle cars peaked in the early 70s and a lot of this was due to this particular vehicle. It was one of the most successful cars of its time and influenced competition to adopt many of its components. It was a classic muscle car design and had a powerful 450hp v8 engine. Can you name this car?

Considered one of the most distinctive muscle cars of its era, this beautifully designed machine was possibly the most recognizable of its day. It's twin nostril grille and integrated front bumper added unique style and its 390 horsepower engine brought the muscle. Combining both and you get the recipe for great American muscle. Can you name that car?

Considered to be one of the very best muscle cars of all time, this vehicle has the largest capacity big block engine ever produced. It's engine is also the most powerful to come out of the classic era of muscle cars. This is 350 horses of classic American muscle. Can you name that car?

Can you name that car? Muscle and style came together to create a beautifully designed monster. With a "semi hemi" 290 horsepower engine able to accelerate 0-60 in 6.4 seconds its power was highly sought after by consumers. They also seemed to love the distinctive design with hood scoop and hockey stick striping.

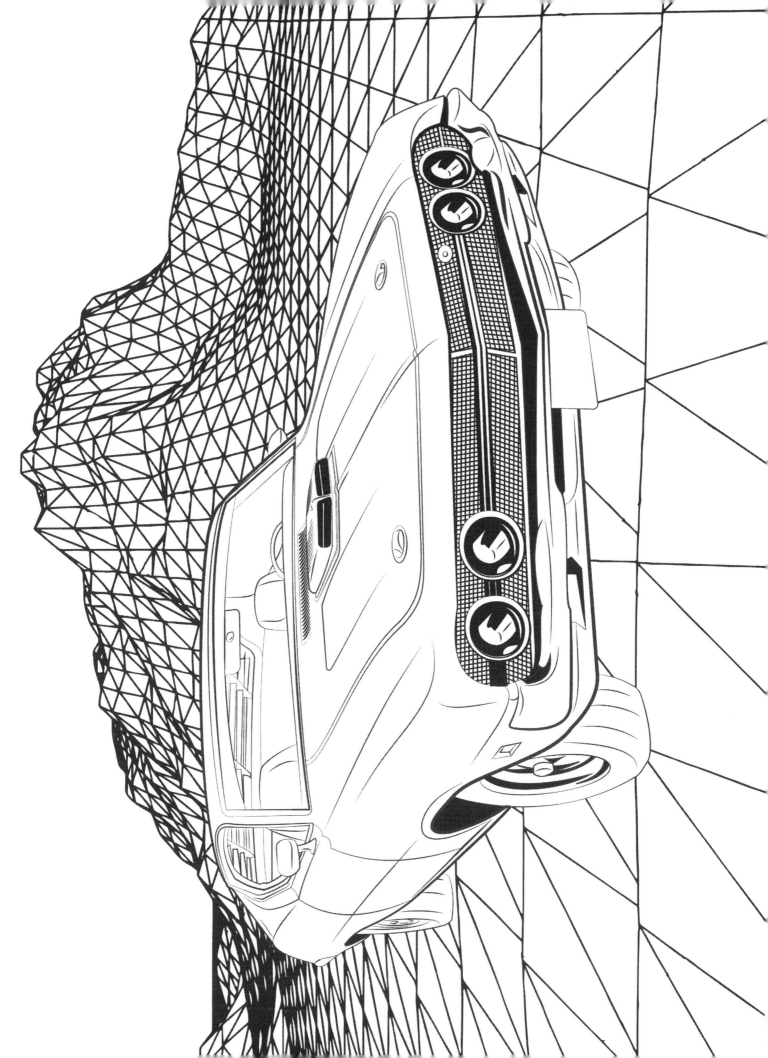

Can you name this car? It may have only had a production life of one year in 1970 but it still made a name for itself in that time. It's ultra sleek aerodynamic yet muscular design and its punch packing 370hp engine where a combination that earned it a strong reputation.

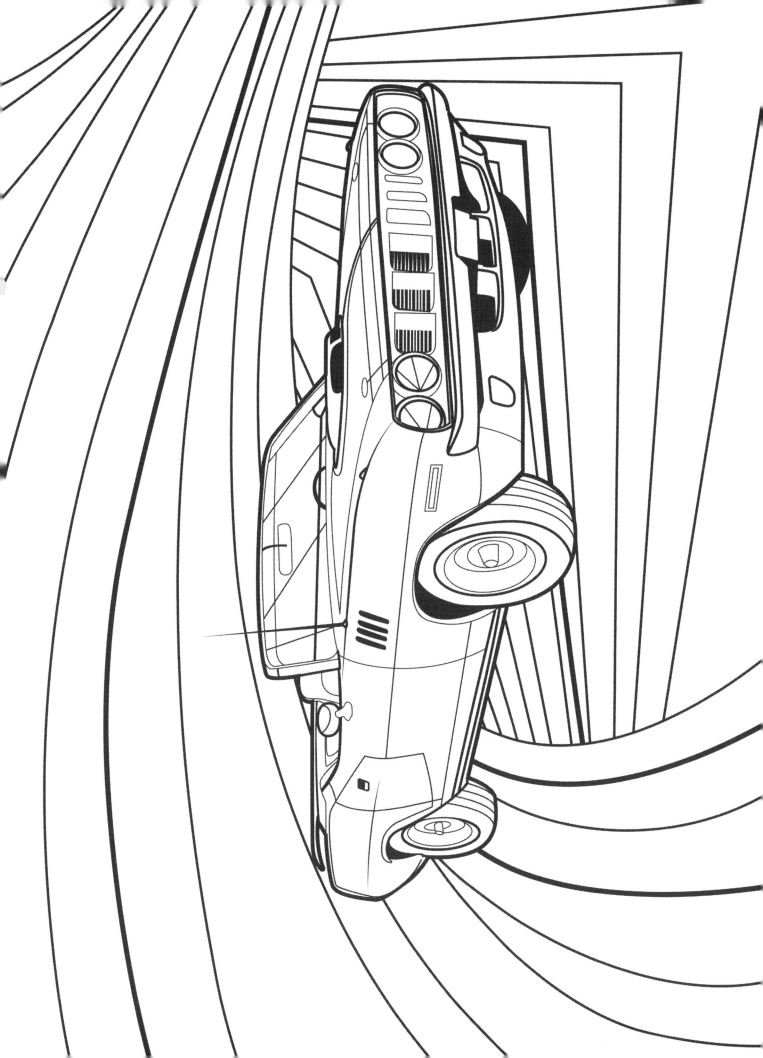

Considered to be one of Americas most prized collectibles. Especially considering muscle cars were made to be powerful yet affordable and today this model is selling for $3.5 million USD! It's muscular body appeals to all muscle car lovers and its 475 horsepower engine isn't too shabby either. Can you name this classic?

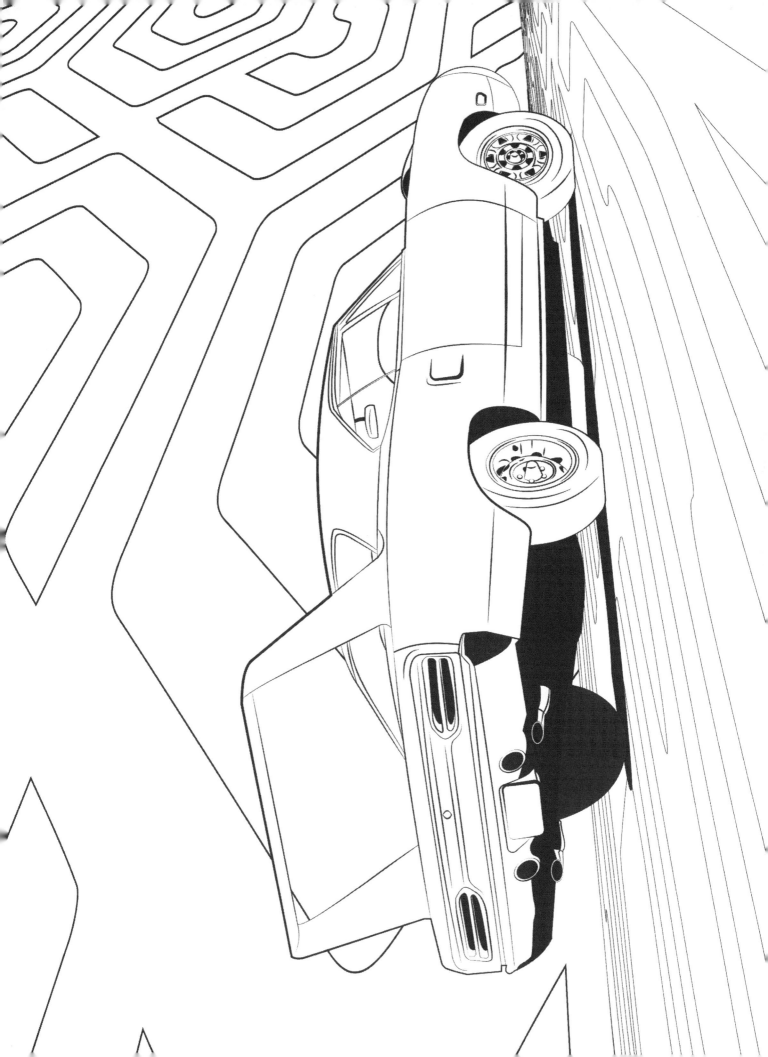

Developed specifically for Nascar racing, the style proved to be too extreme for most consumers tastes. It's large wing and nose cone added weight that only benefited at speeds excess of 60mph. It's V8 engine held 425 horses and accelerated 0-60 in 5.5 seconds respectively. Can you name this muscle car?

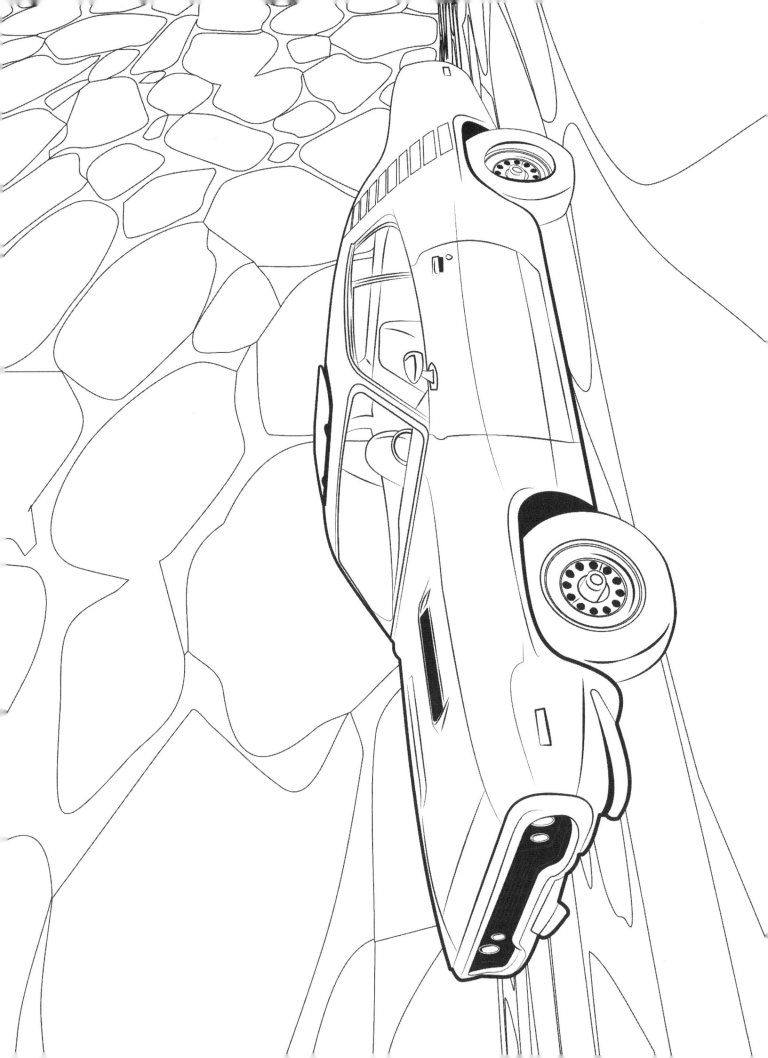

Most fans of this model believe it to be an upgrade in appeal from its predecessor. The 1972 model added a stylish new grille and tail lights but had a drop off in the performance category. All this was done to keep the pricing low. Can you name this muscle car?

Also Available from BSW Press!

ACT Automotive Coloring Theeerapy

Inside the Lines:
European Icons

by Brandon & Steve Wilcox

Scan the QR code with your smartphone for more information and be sure to visit www.sdubconcepts.com where you can register to get email updates and news including free downloads!

Be on the lookout for these upcoming *Inside the Lines* titles!

_ Exotica!
_ Off-Road
_ Classic Americana
_ Wheels of Italy
_ German Heritage
_ Automotive Mandala, and More!

Be sure to Like us on Facebook and follow us on Instagram and twitter! Take care, be safe, and always stay *INSIDE THE LINES!*

Made in the USA
Middletown, DE
01 March 2021